a
CHRISTINE
MACKENZIE
design

www.zookytheterrier.com

www.ingramcontent.com/pod-product-compliance
Lightning Source LLC
Chambersburg PA
CBHW081145180526
45170CB00006B/1933